How to Draw

Manga Chibis

In Simple Steps

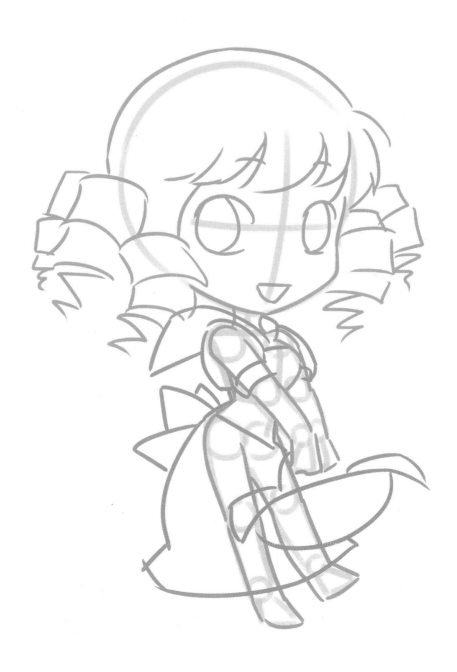

First published in Great Britain 2016

Search Press Limited
Wellwood, North Farm Road,
Tunbridge Wells, Kent TN2 3DR

Reprinted 2017, 2018

ISBN: 978-1-78221-344-4

Printed in Malaysia by
Times Offset (M) Sdn. Bhd.

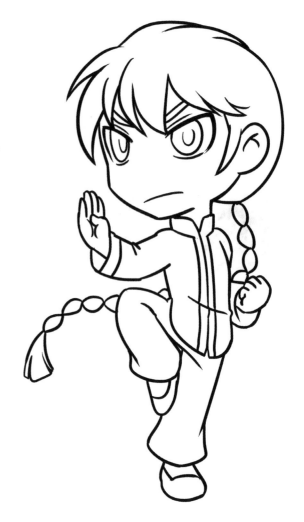

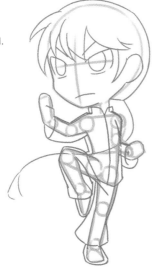

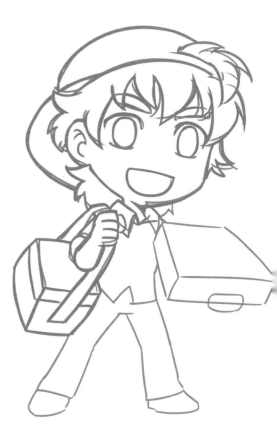

Illustrations

How to Draw
Manga Chibis

In Simple Steps
Yishan Li

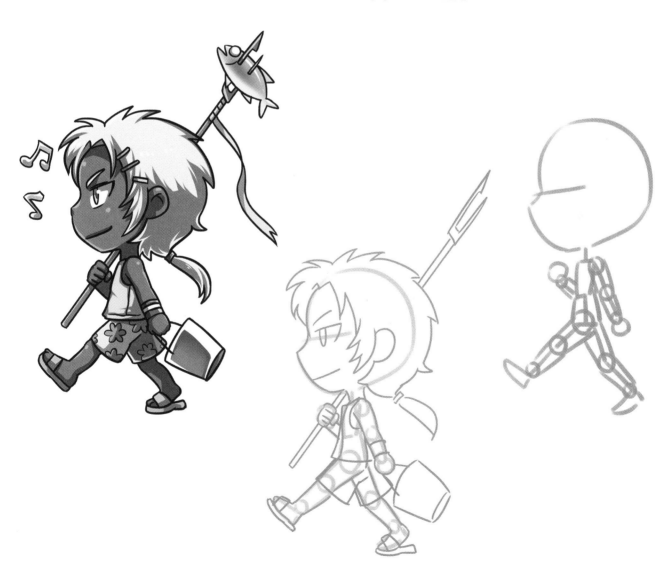

Search Press

Introduction

Hello, my name is Yishan Li, and welcome to my series of *How to Draw Manga* books.

Manga originated in Japan and has since grown to have an impressive worldwide following. *Chibi* is a Japanese word meaning 'small person', and in manga terms it is a simple and cute style of drawing. Normally chibi characters are 'super-deformed' to the most adorable way possible – huge eyes, tiny nose (or no nose), child-like bodies and very expressive emotions. The chibi style is usually used in scenes which are funny and/or cute.

Chibis are relatively easy to draw compared with normal-sized manga characters because the body structure is simpler and faces are more stylised. So this is a good starting point if you are thinking about drawing manga.

With the easy-to-follow steps, you will see how a chibi character can be built from basic shapes and outlines. Each drawing starts with a rough pencil sketch of the most simple shapes, outlined in blue, then different coloured pencil lines are added to build up the details (it doesn't matter what colour you use as long as they are easy to erase later on). Once all the components of the sketch are in place, I use a waterproof black ink to draw the outline. Make sure your lines are smooth and solid for the final drawing. Once you have erased all the marks that were done in pencil, you can add colour either by scanning it into your computer and using an image processing program such as Photoshop, or by hand with water-based markers such as Copic. All the images in this book are coloured using Photoshop.

Finally, once you have done your practice based on this book and moved on to create your own characters, remember all the basic elements you have learnt here – use simple forms initially when you sketch and then build on these and add more detail. Most importantly, use your imagination to make these details interesting and help tell the story. Your character should have a personality, a rough background story, and maybe a profession as well.

Have fun!

Happy drawing!

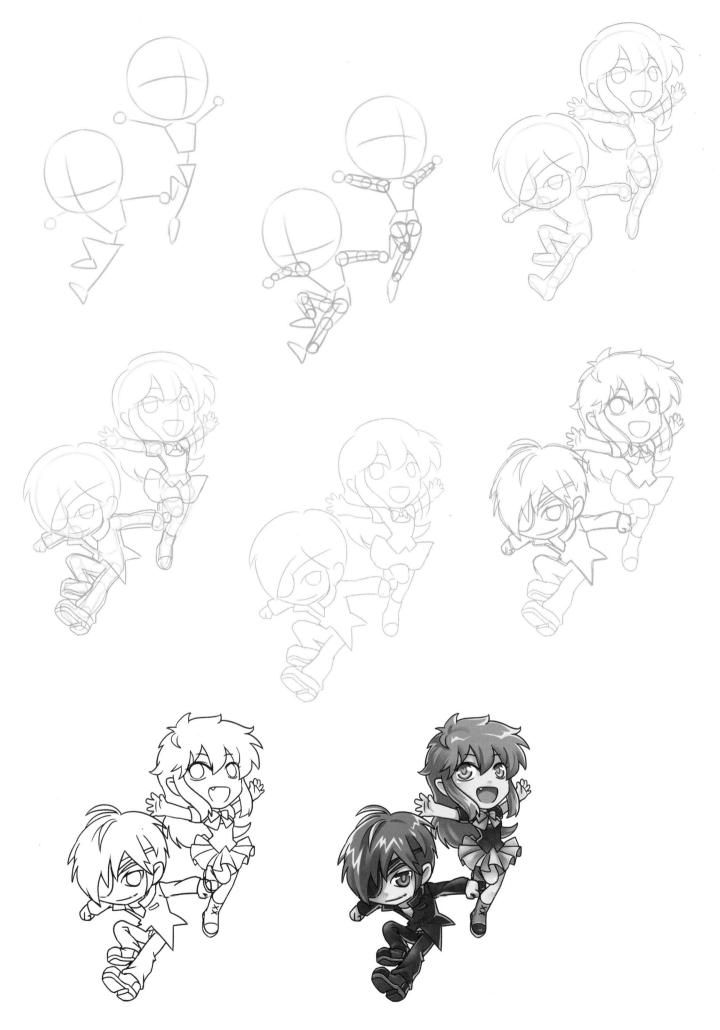

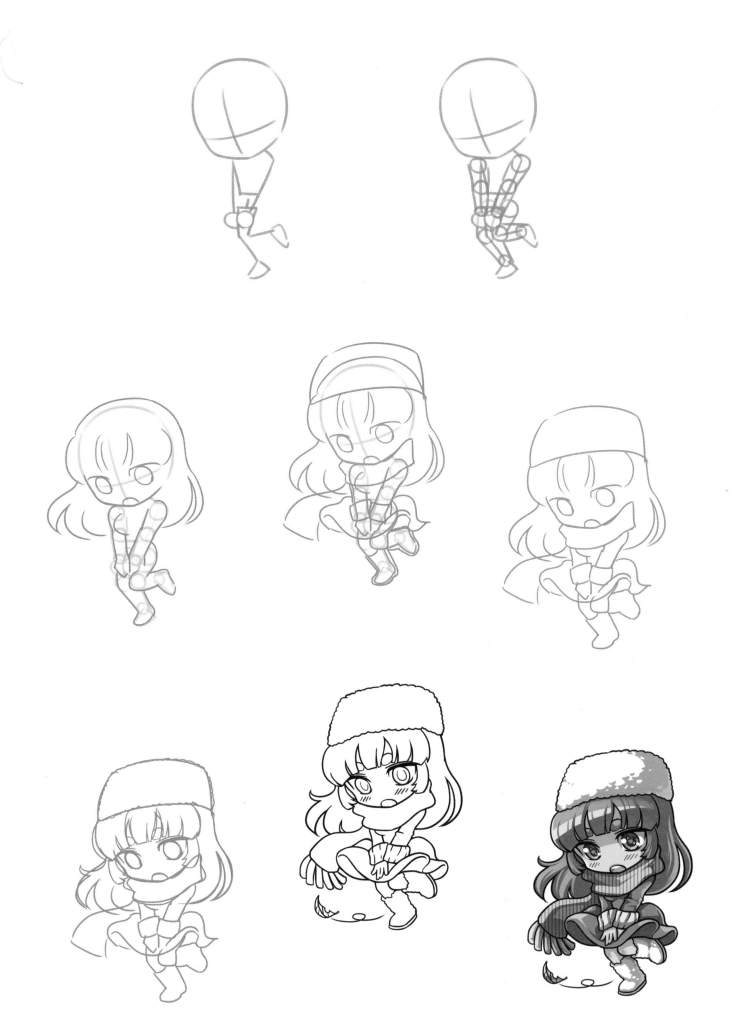

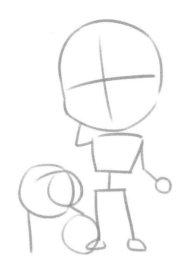
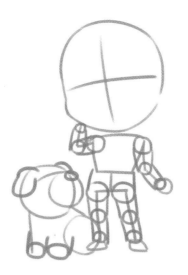
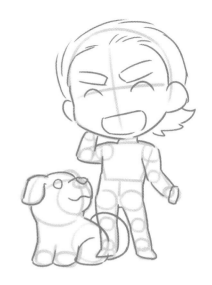

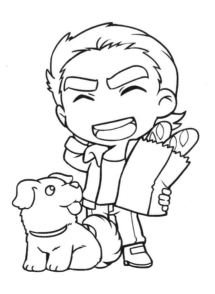
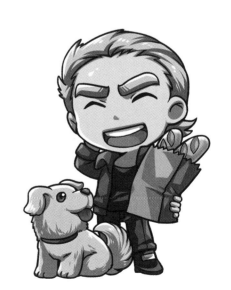

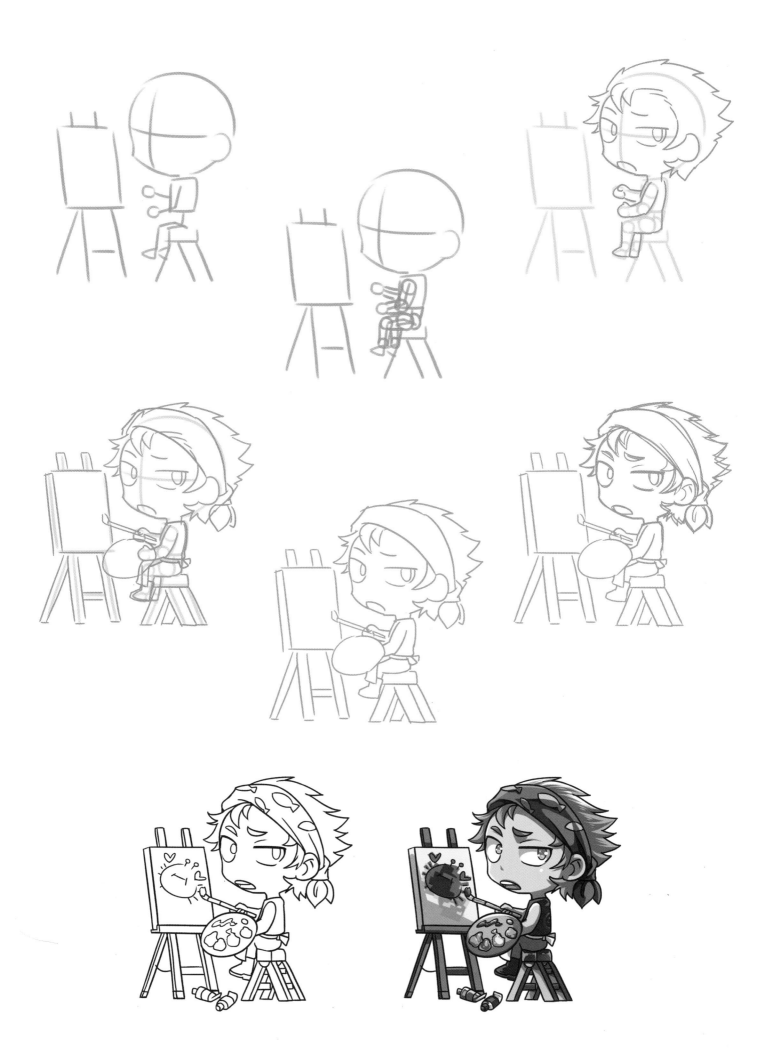

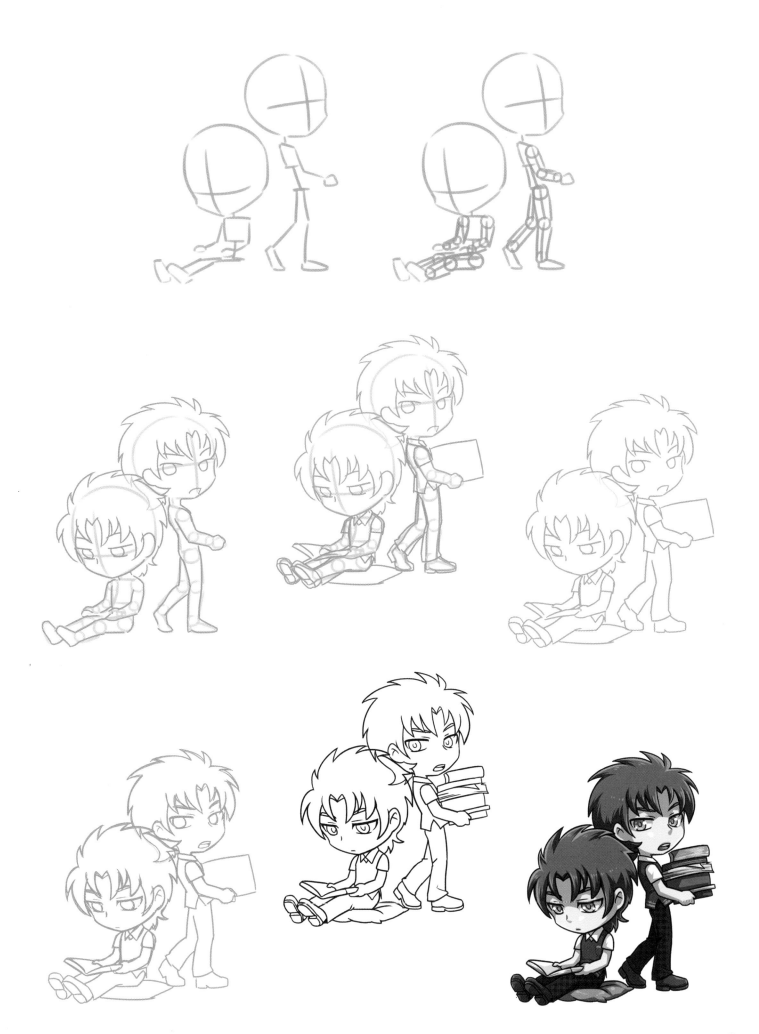

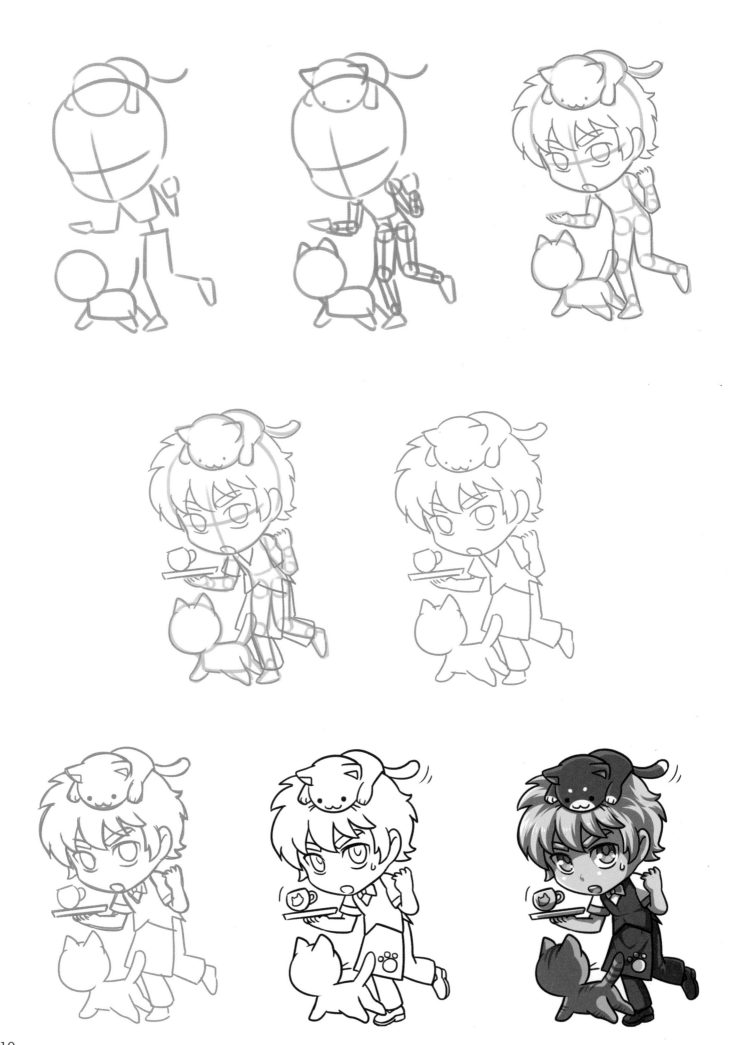

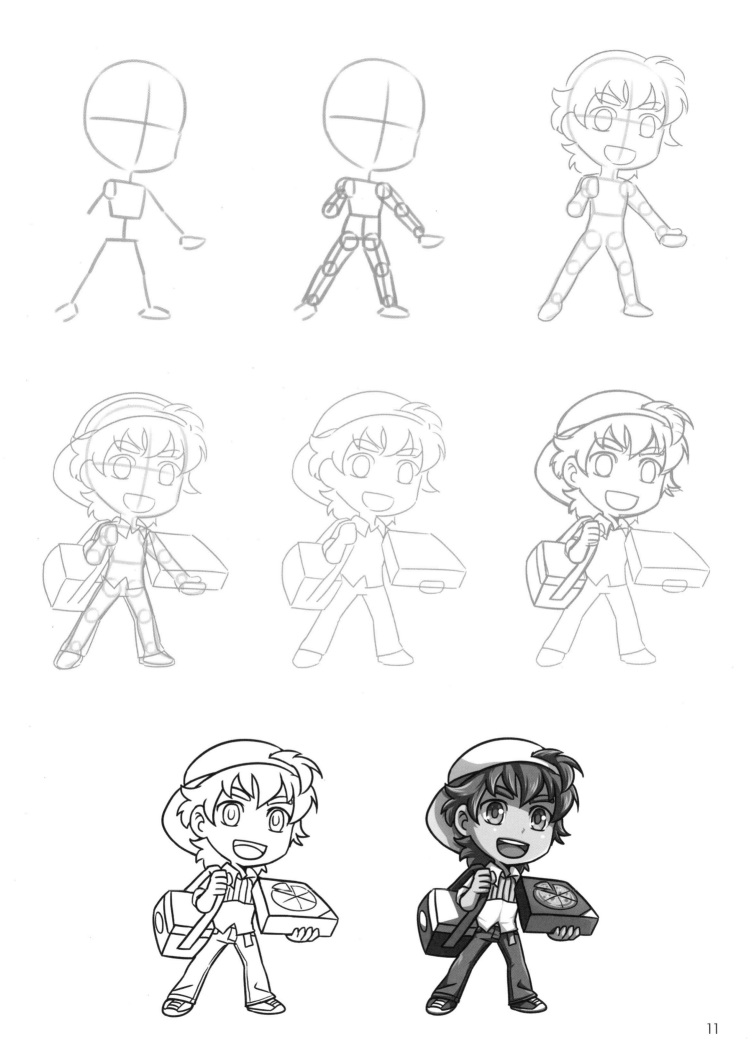

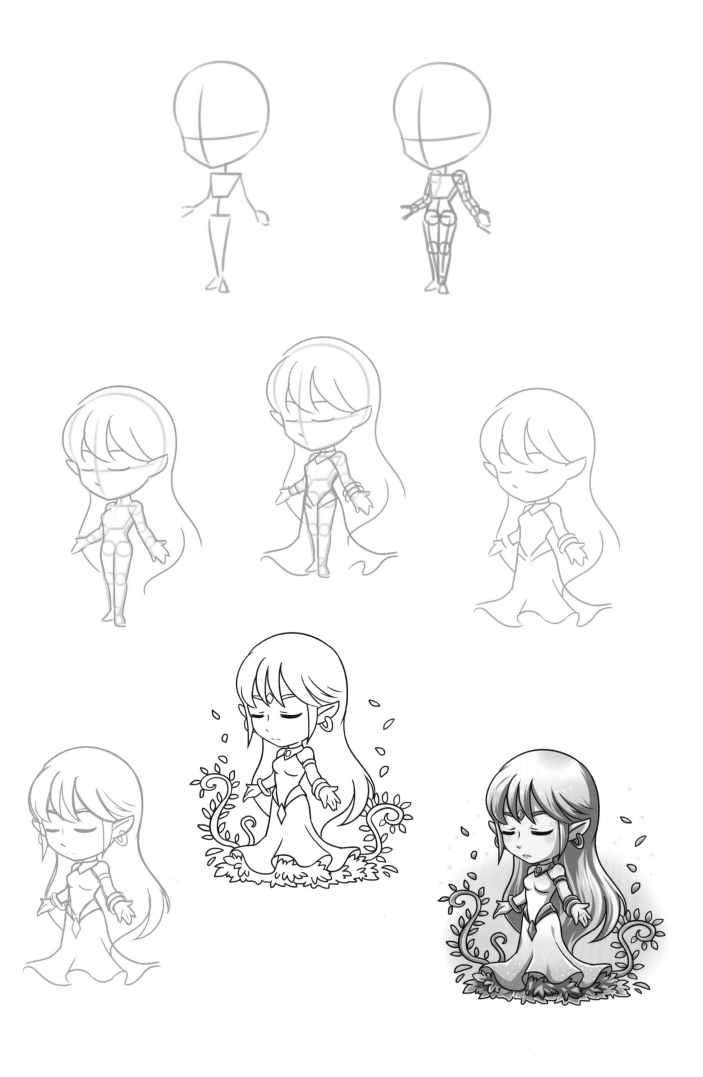

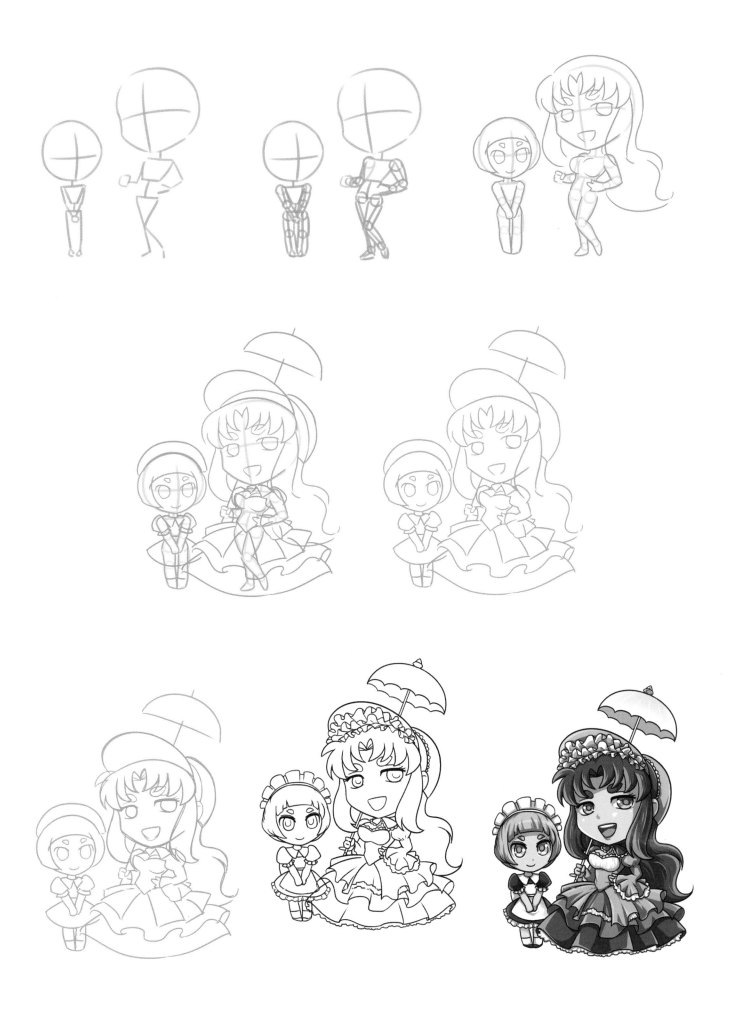

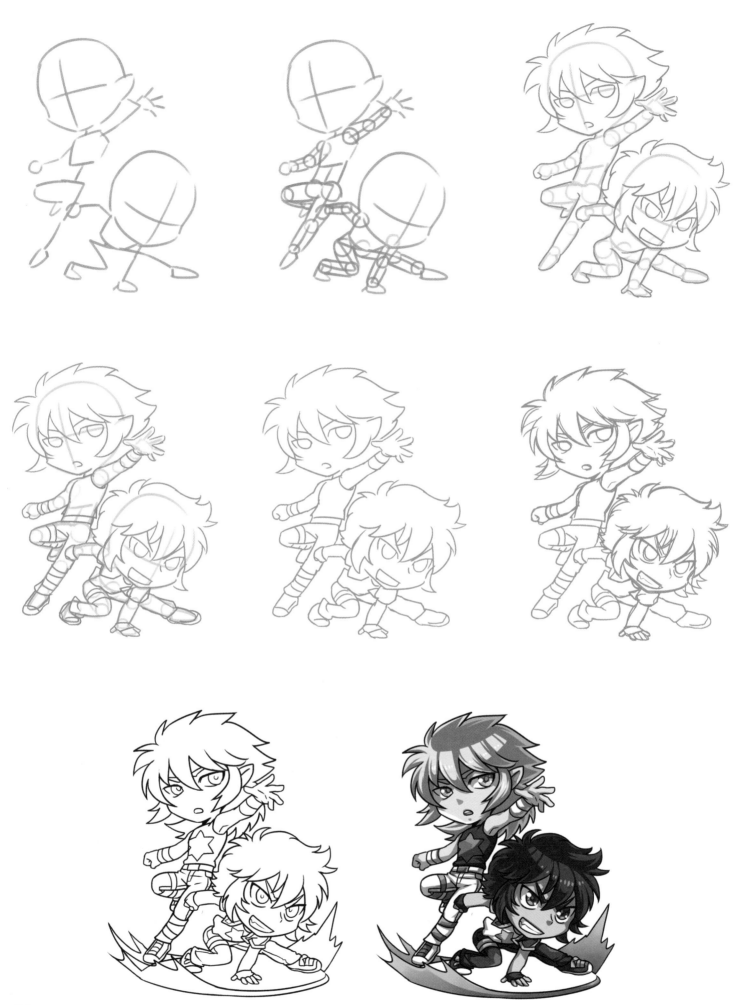

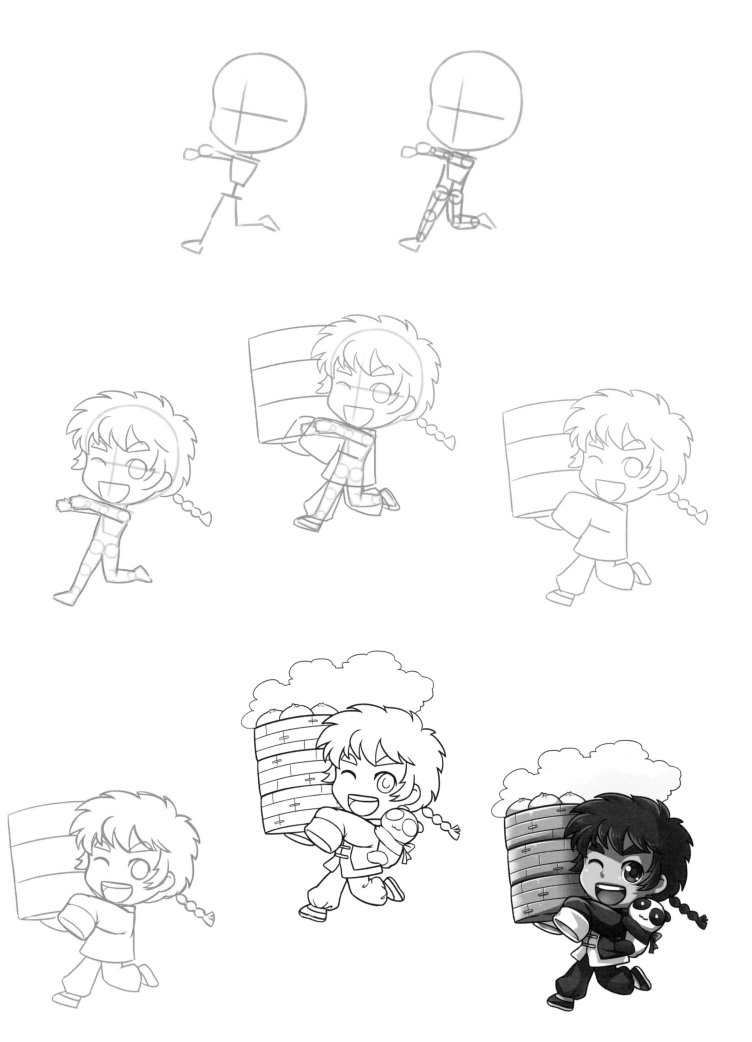

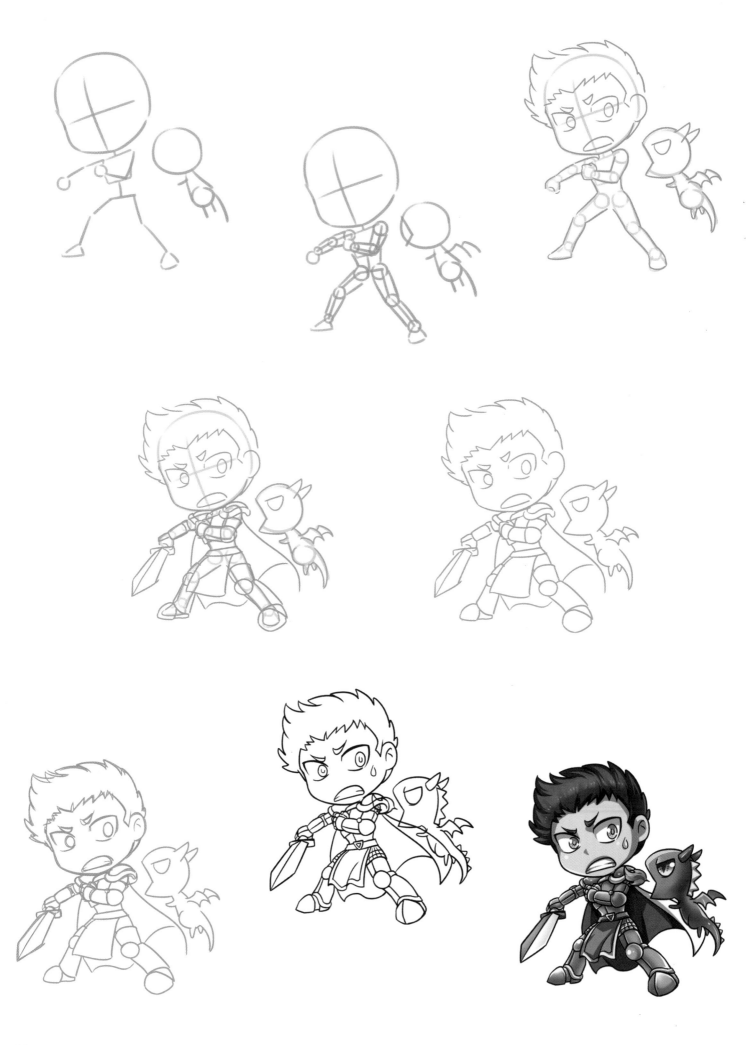

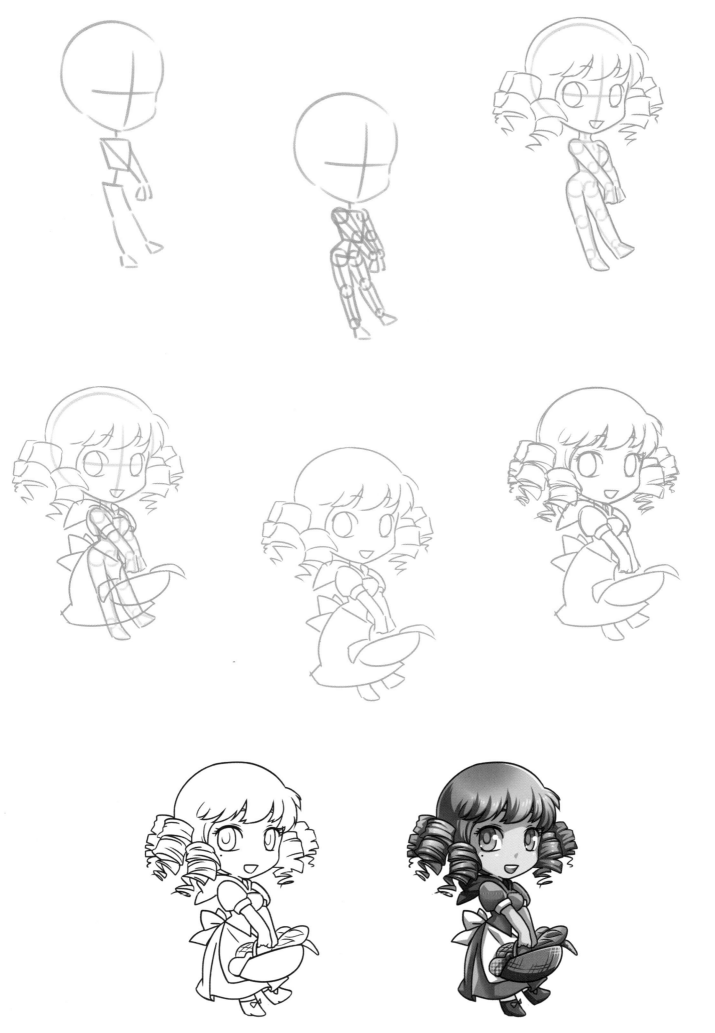

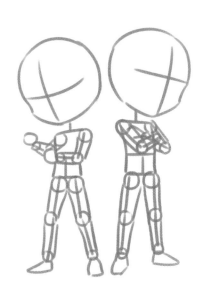
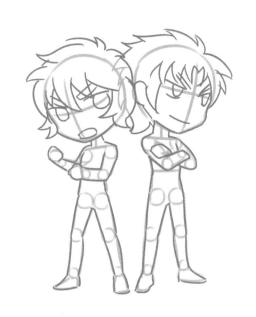
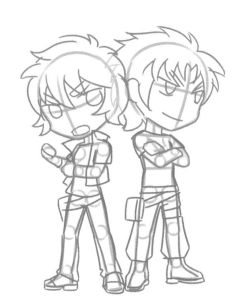
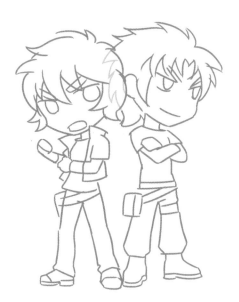
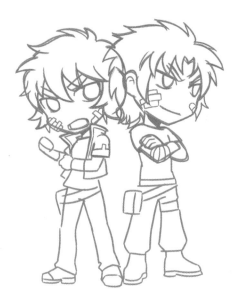
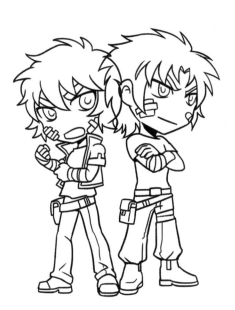
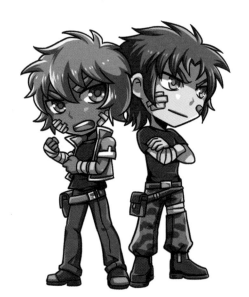

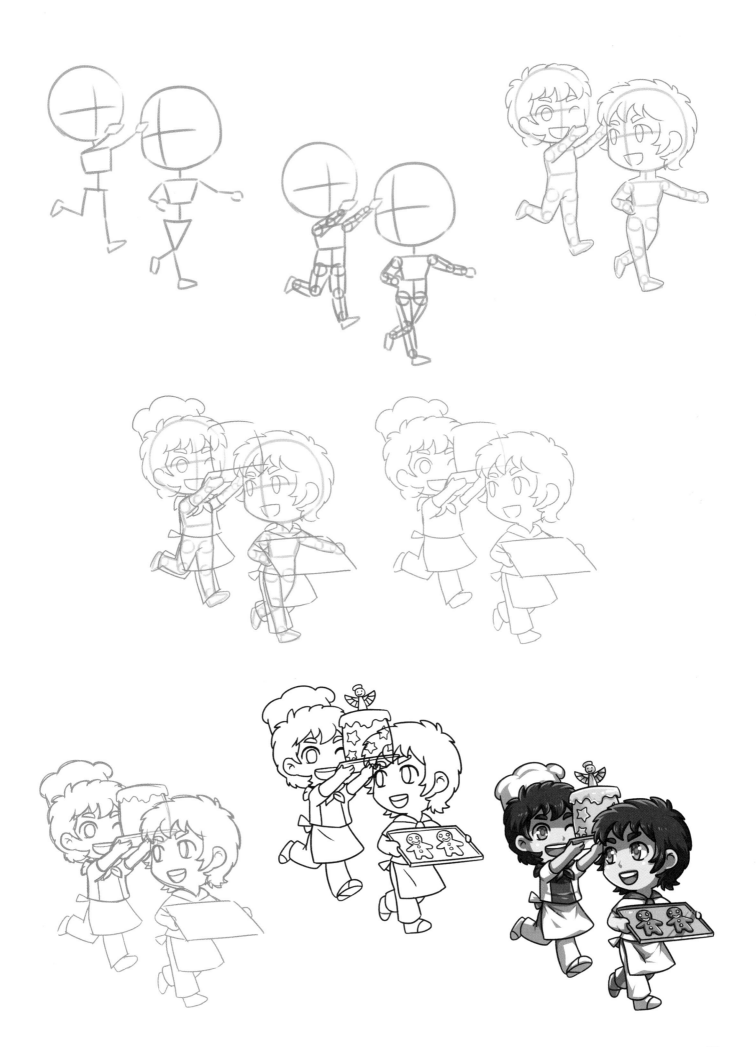

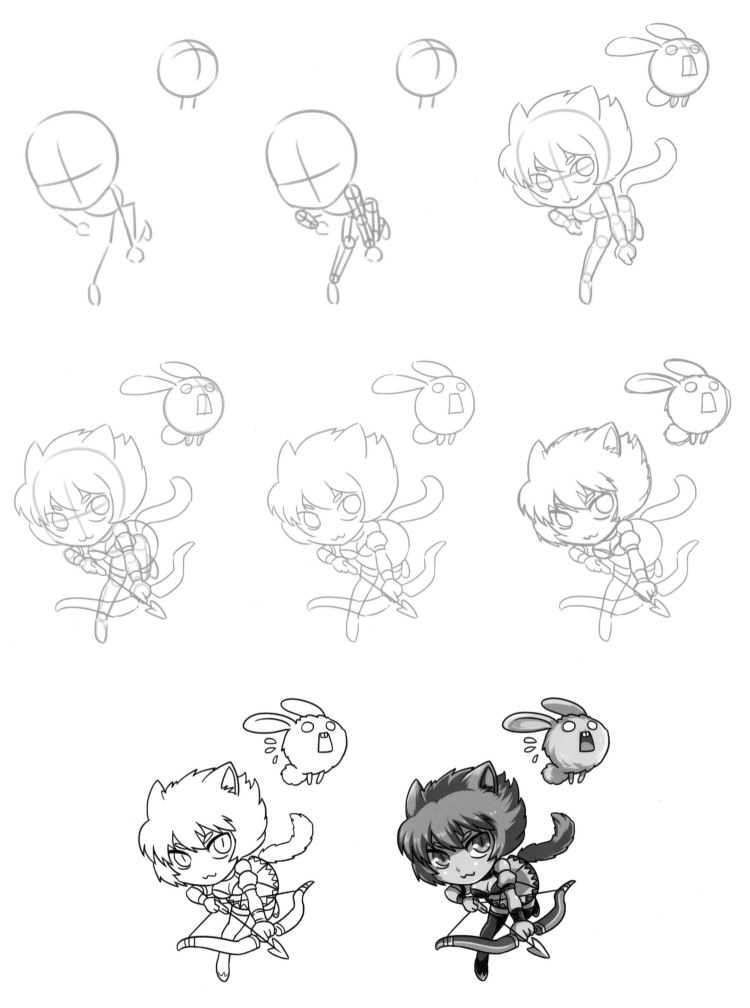

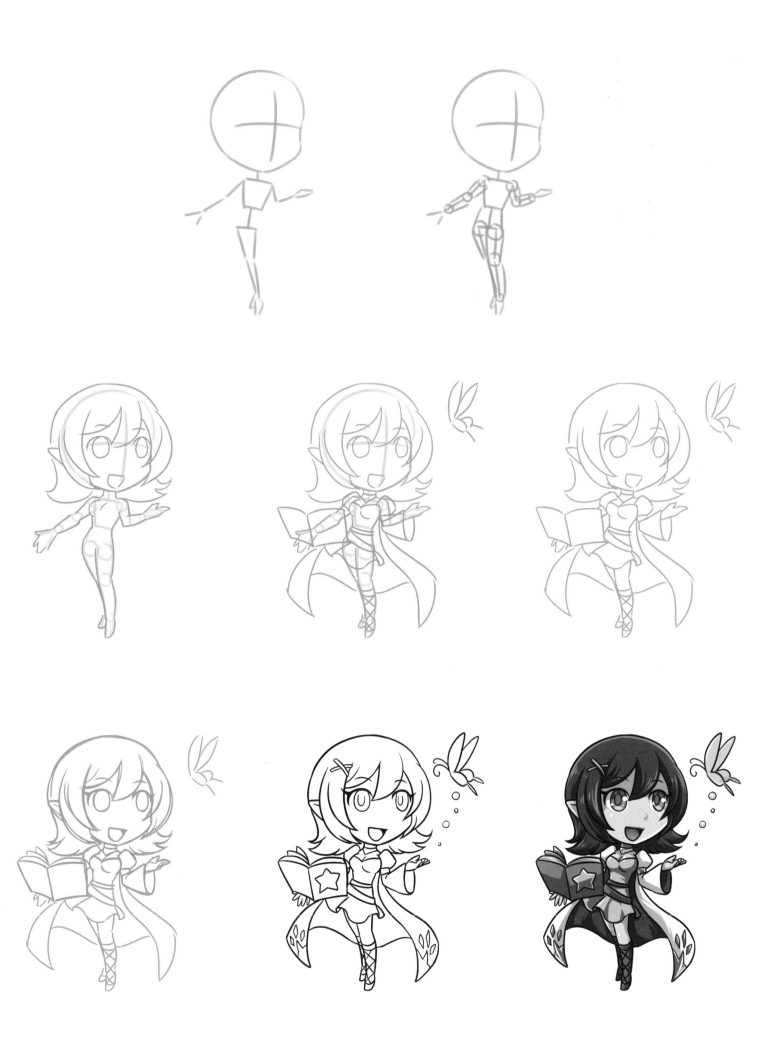

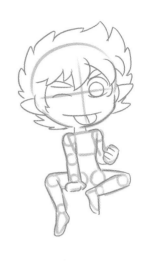
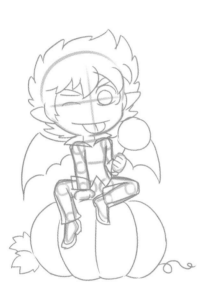
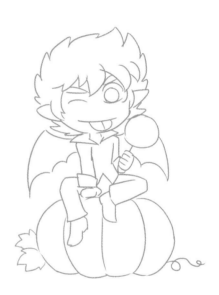
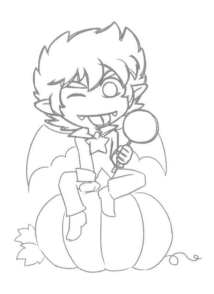
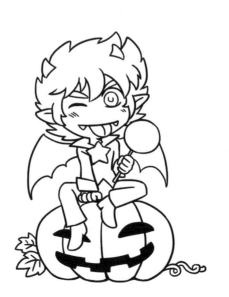
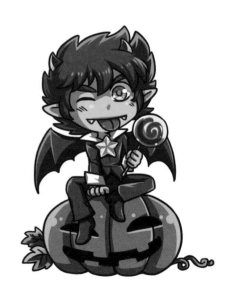

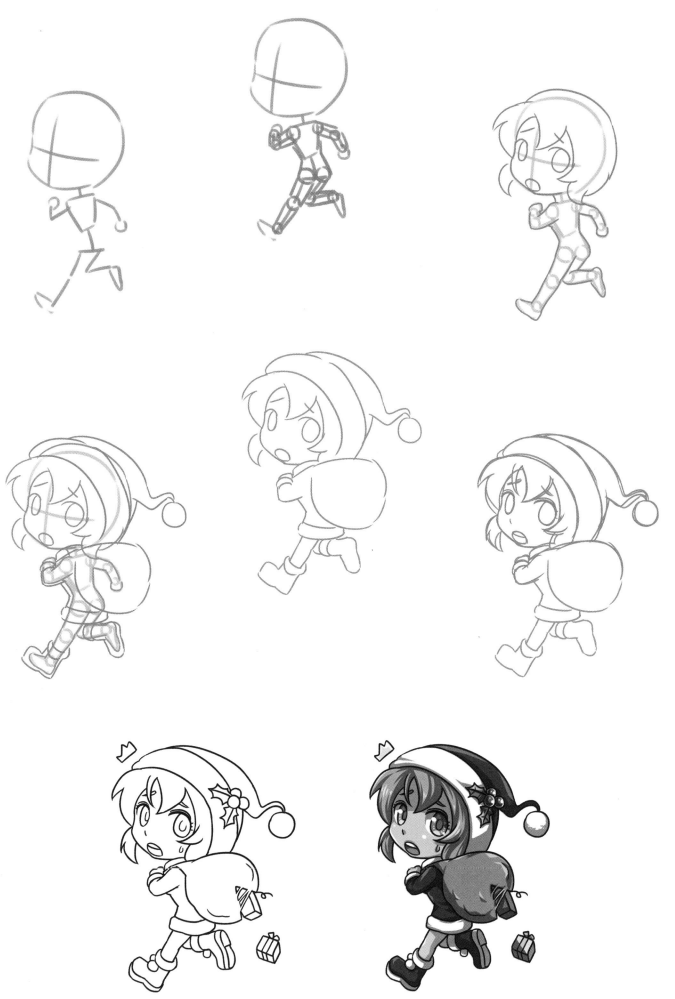

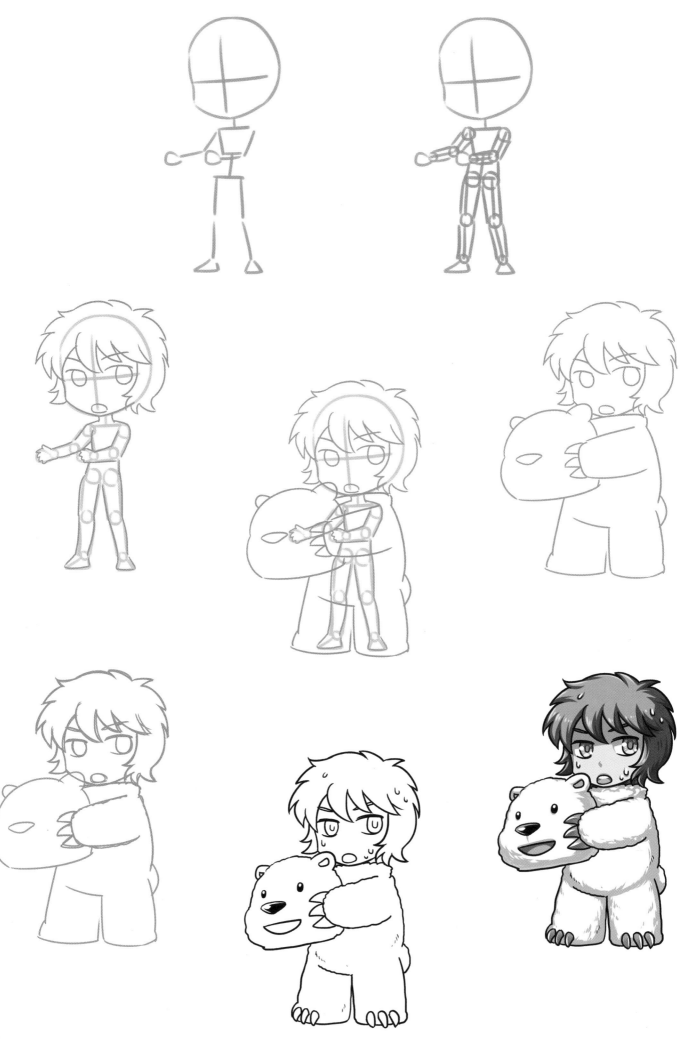

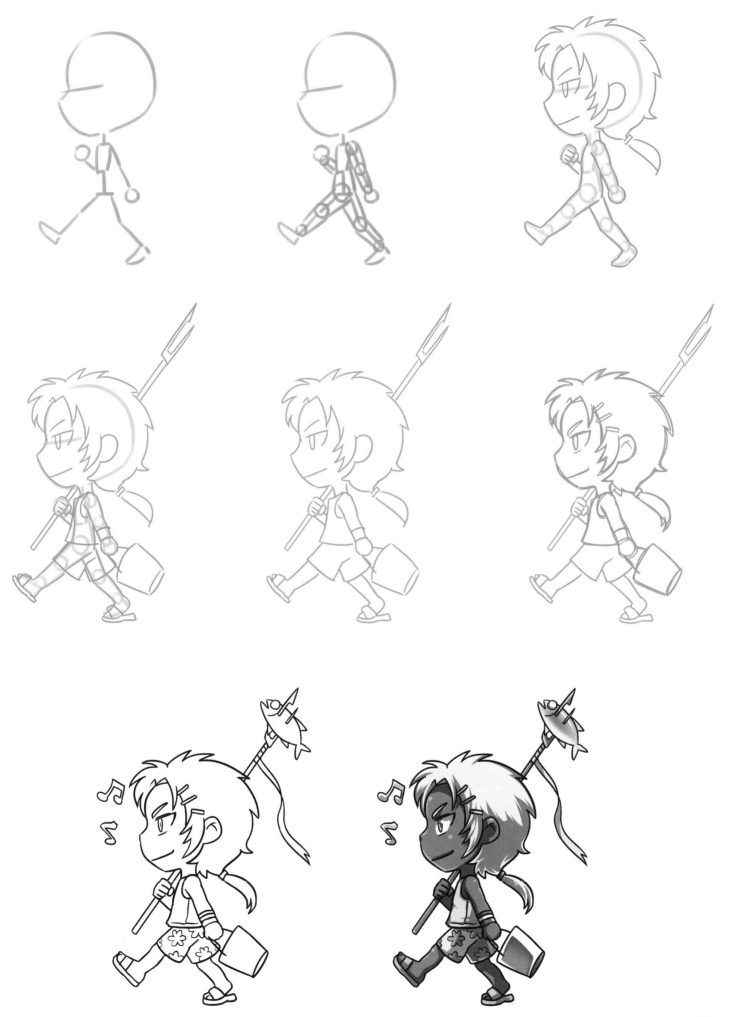

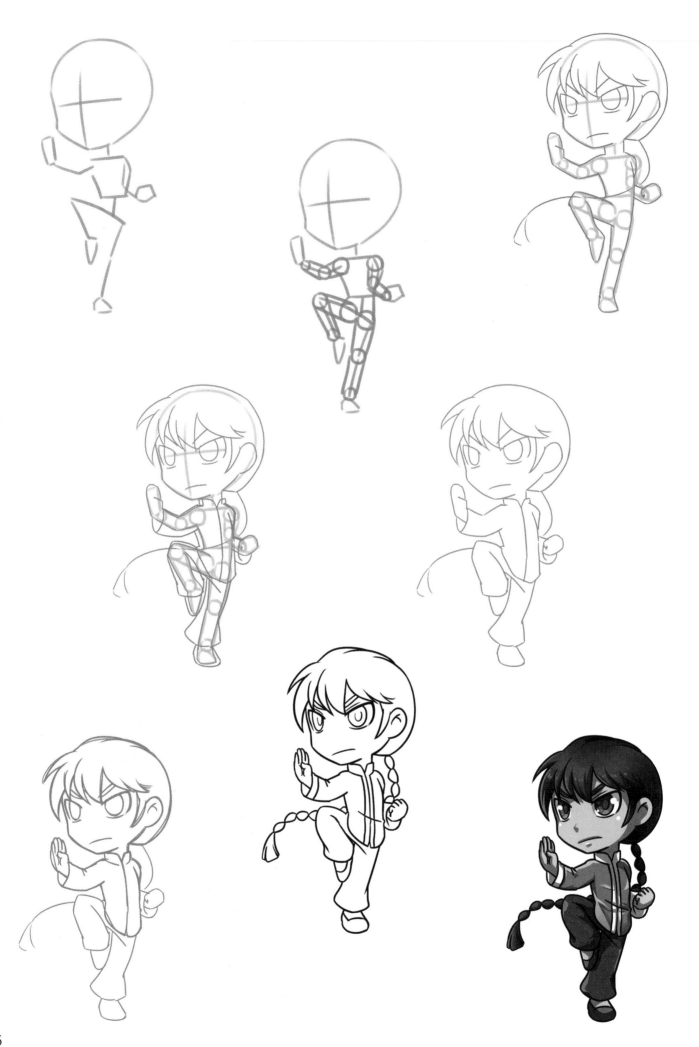

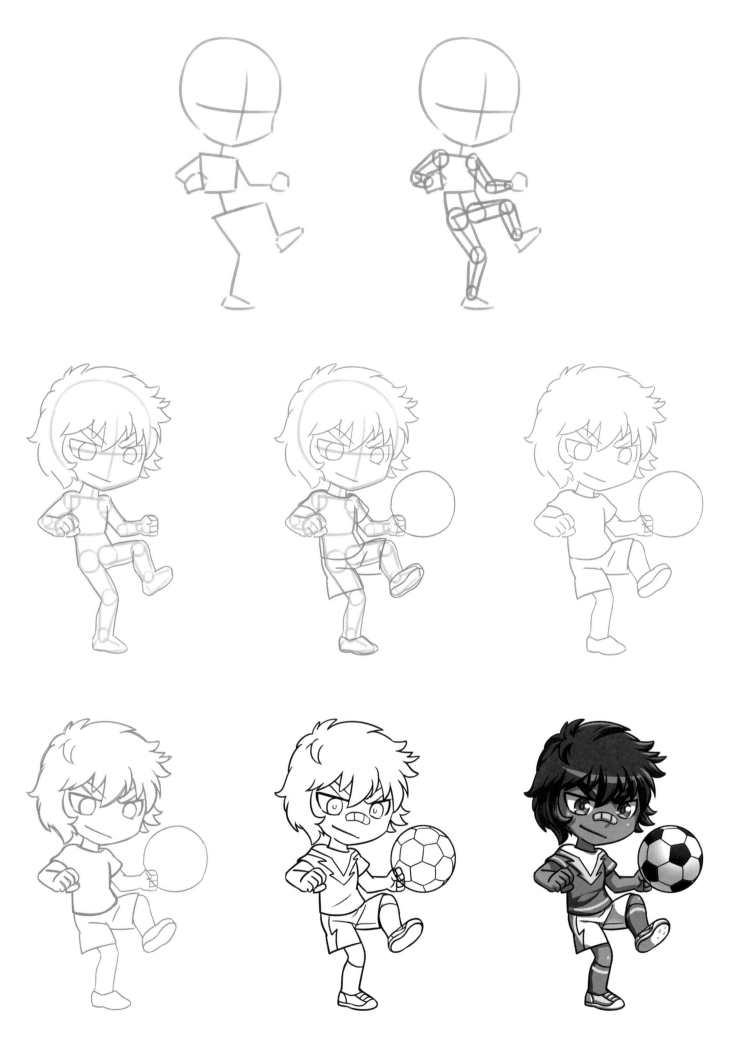

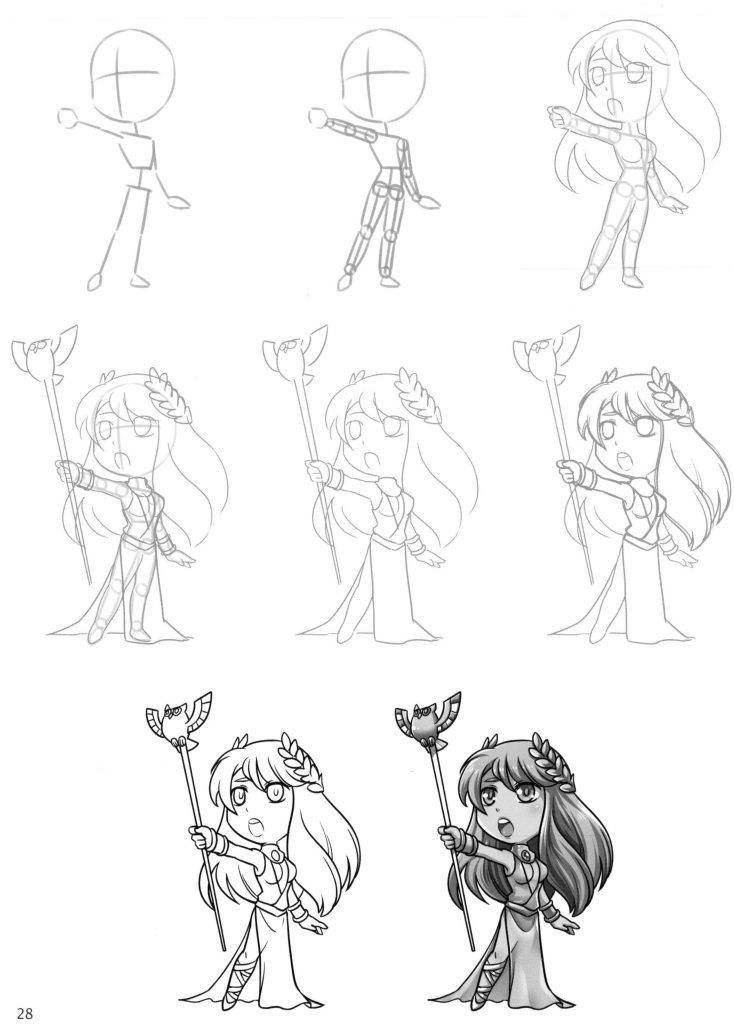

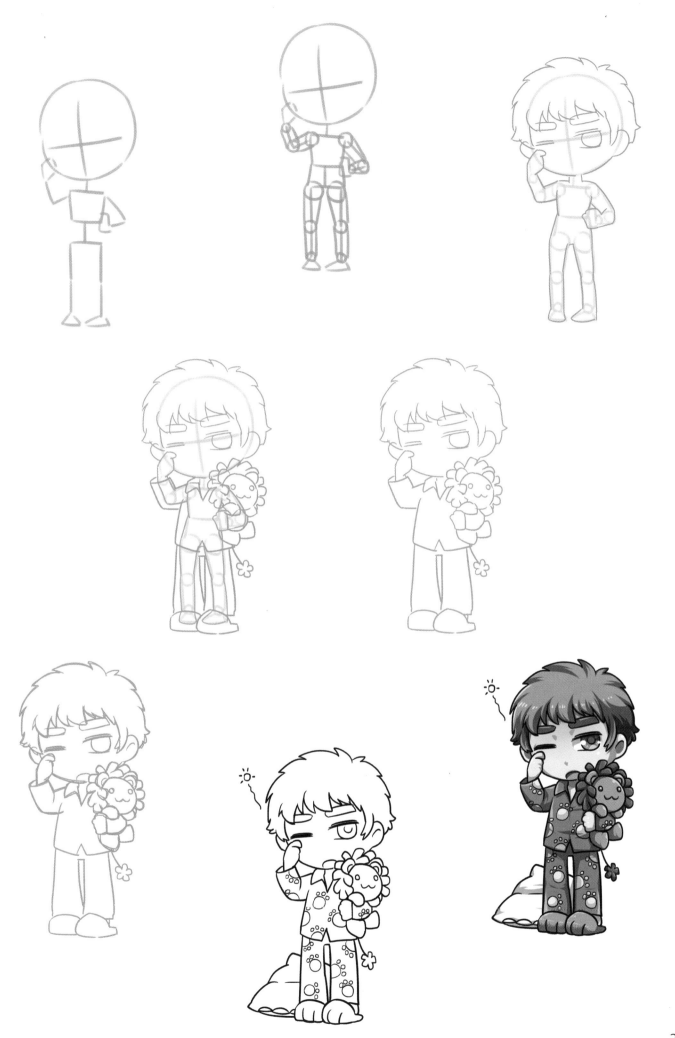

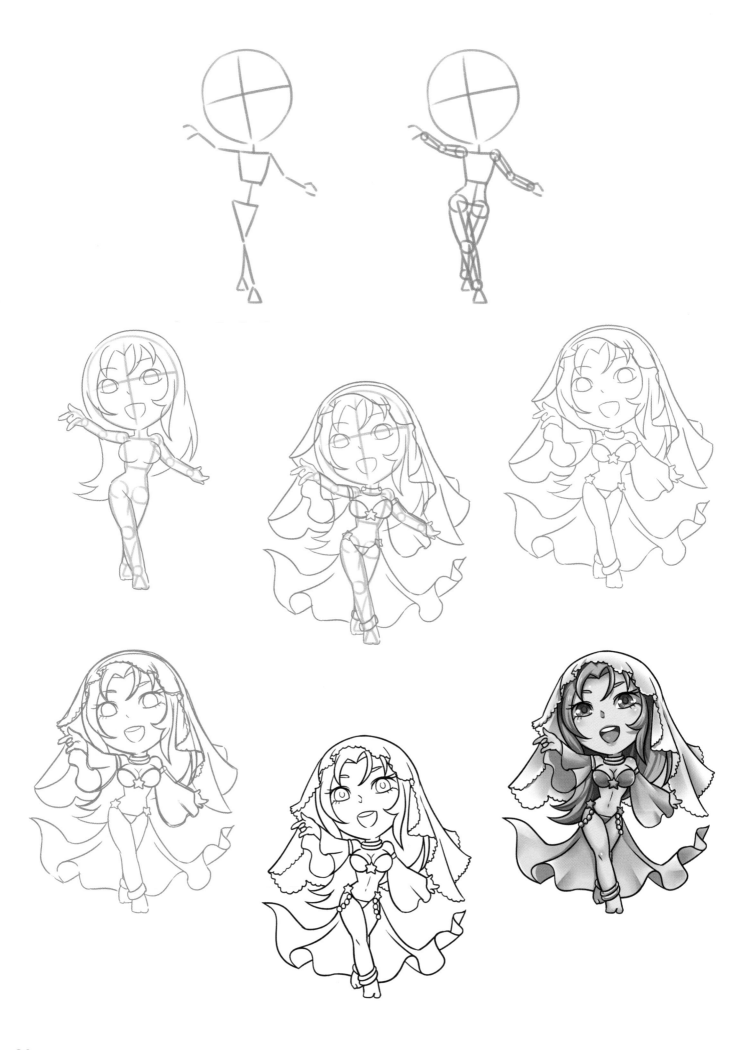

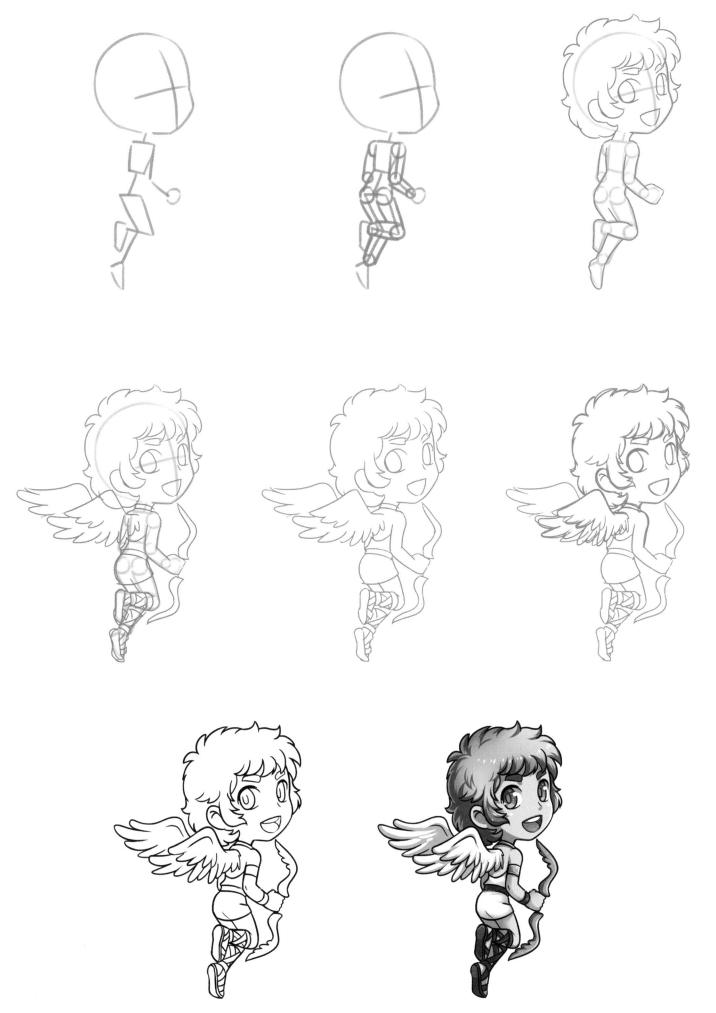

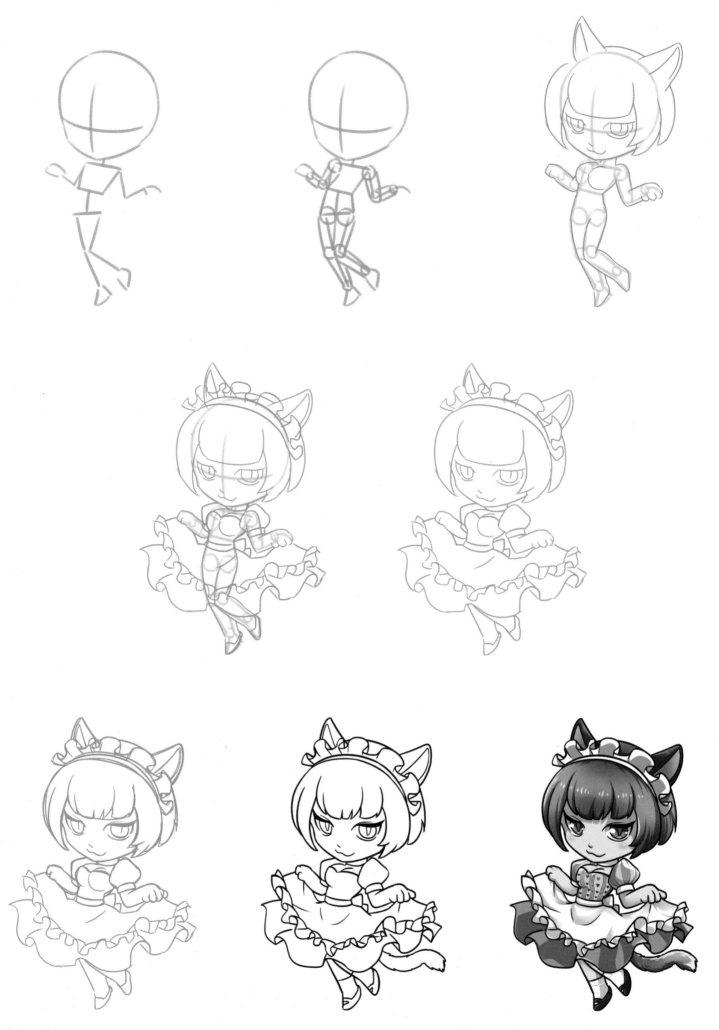